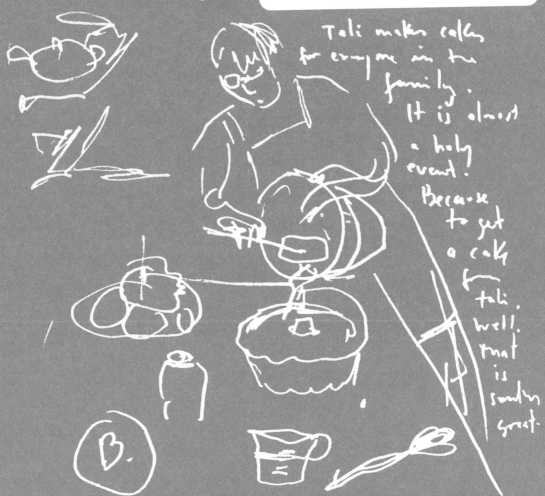

CAKe

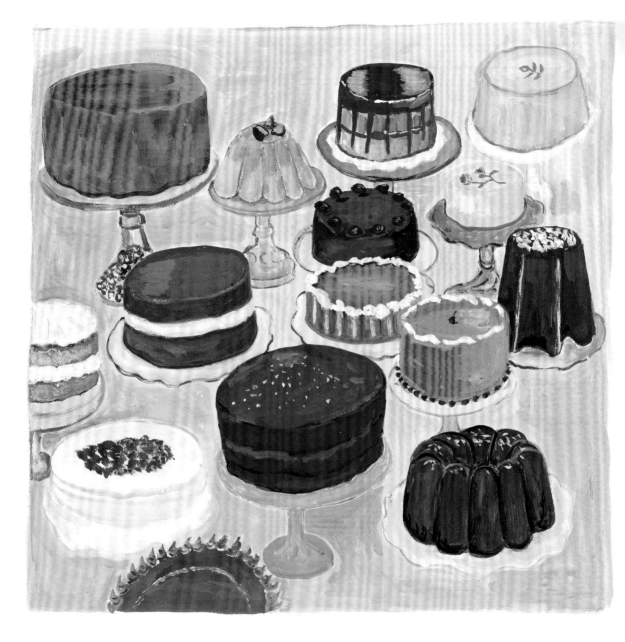

CAKE

Maira Kalman

WITH RECIPES BY

Barbara Scott~Goodman

PENGUIN PRESS
NEW YORK
2018

The
TABLE
of
Contents

The First Cake

The First cake I Remember was on the terrace of my aunt Shoshana's apartment in Tel-Aviv. It was a chocolate cake. The summers were Long and Hot. Shoshana would take her three children, Tali, Azriel. and Orna, and my sister Kika and me to the beach for a few hours every morning. After the beach, we would walk home, shower, and gather on the terrace. We lay on the cool stone tiles. Lolling about came easily to us. There we were each given a plate with a slice of chocolate cake and a clump of green grapes. I am not sure we ever said thank you. But isn't that how it is.

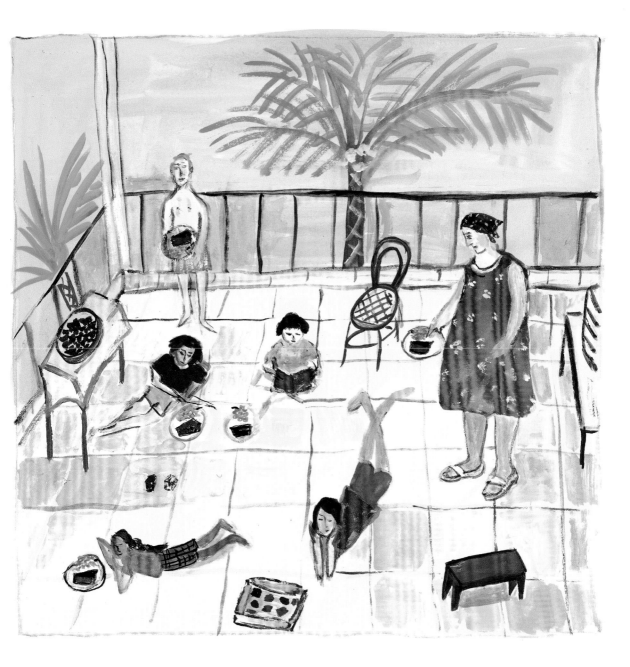

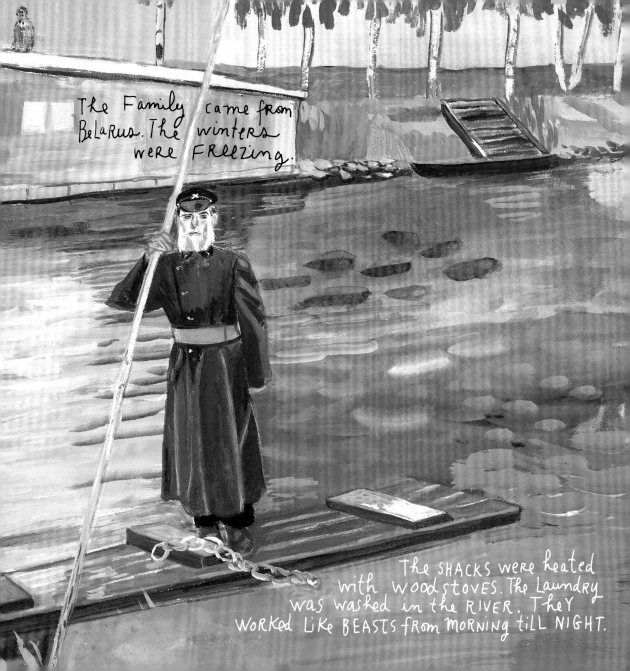

The Family came from BeLaRus. The winters were FREEZING.

The SHACKS were heated with WOODSTOVES. The Laundry was washed in the RIVER. THEY WORKed LiKe BEASTS from MORNING till NIGHT.

And yet, so many cakes were baked.

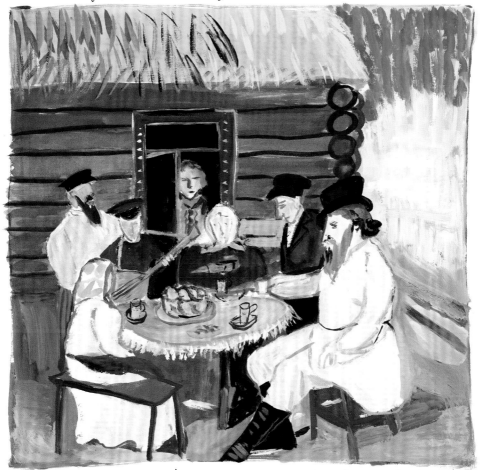

The families sat around the table and told stories and sang. They drank very hot tEA in glasses and ate cake.

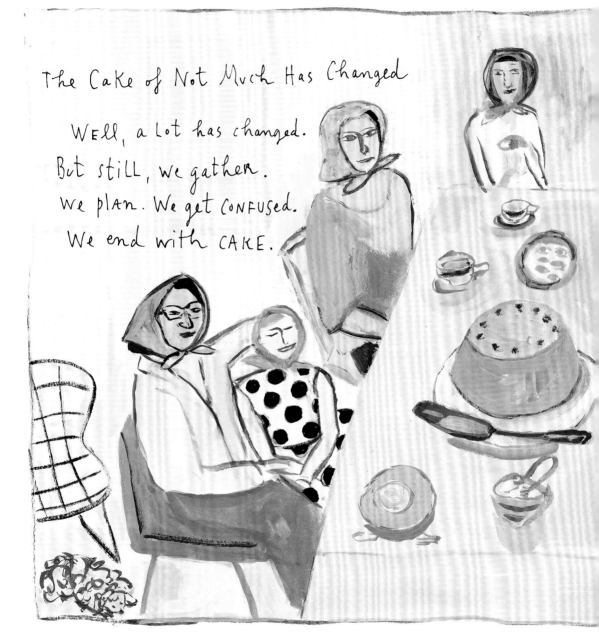

The Cake of Not Much Has Changed

WELL, a lot has changed.
But still, we gather.
We plan. We get CONFUSED.
We end with CAKE.

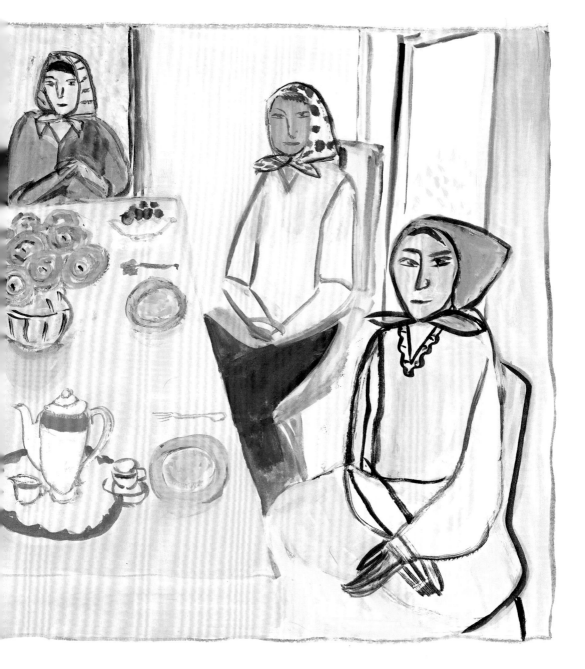

The Cake of Being Kind, Not Angry

Once my grandmother took all the cousins to the circus in Tel Aviv. Everyone was very excited. After the circus, my grandmother and my cousins were running for the bus. As she was running, the heel broke off my grandmother's shoe. She hobbled and limped as fast as she could to catch the bus. The children were doubled over with laughter at the sight of her plight. When they got home, they were asked how the circus was. But they could not remember anything. The only thing that interested them was my grandmother's broken heel, her despair and their merriment. The sweet thing is that my grandmother was not angry at all with the children. She made a cake and they all ate it. Orna, who told me this story, thinks it was a babka.

The Ninth Birthday

My parents invited all of my girlfriends.
All the Girls wore FANCY dresses.
We Really knew how
to dress.
My dress was
White with a
Red Sash.

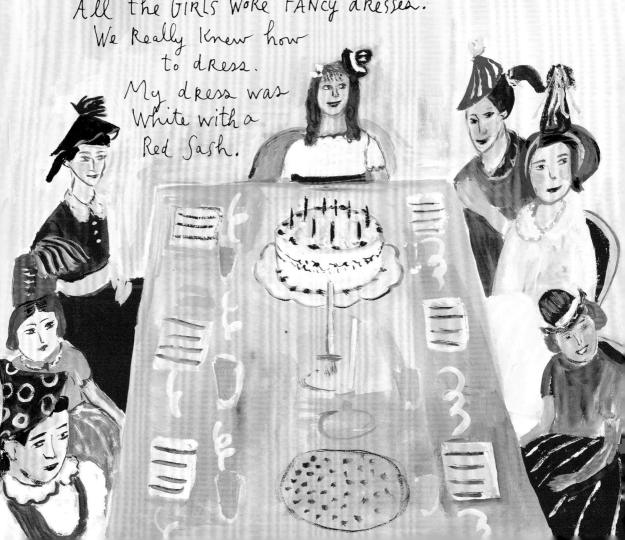

My Father, Mother, Sister, and I posed.

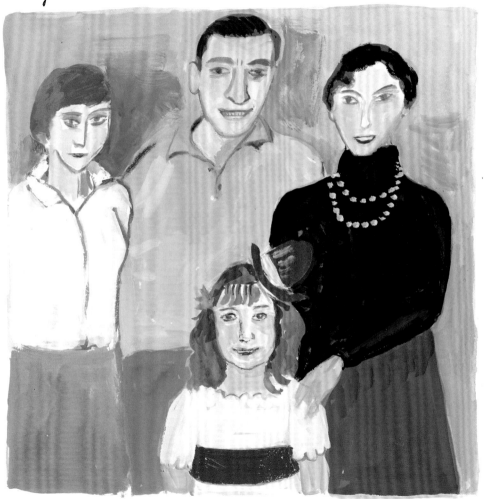

I can safely say, I was the happiest one there.

My Ringlets were shiny. I was
full of endless self-confidence and joy.
The future was ahead of me.
The cake was probably from
Mother's Bakery, down the
block from our apartment.
They made an excellent
 mocha cream cake.

Welcome

Most of us love cake and take great comfort and delight in eating it. In addition to being a delicious treat, cake evokes powerful memories from our pasts. We remember cakes from landmark occasions like childhood birthday parties, holiday meals, weddings, and funerals. We recall the cakes we ate in bakeries and restaurants, the ones we ate at home or while traveling. There are strong emotions and resonant stories that go with cakes. I have baked many elaborate cakes for birthdays, dinner parties, and holidays, but my most memorable cake is a simple cinnamon-peach number that I threw together for a beach picnic many summers ago. I still remember that sunny afternoon, when my young daughters and I were sitting by the water and eating that juicy cake, like it was yesterday. Sweet memories indeed.

People think that cake is kind of a big deal, and it is. Serving cake for dessert can turn a simple dinner into an occasion, and nothing says "Let's celebrate" quite like it. It is often the pinnacle of a party. After the birthday kid makes a wish and blows out the candles on the cake or when the bride cuts the wedding cake, it signifies that, sadly or mercifully, the party's almost over.

When I gaze into a bakery window, I admire the cakes and confections baked by professional pastry chefs and master bakers. I am in awe of their craft, talent, and precision. But what I truly love are homemade cakes—you know, the ones where the layers are a little lopsided and the frosting looks like the kids or grandkids were helping out in the kitchen. I am crazy about tea cakes, pound cakes, and sheet cakes. These are simple treats to be savored with a cup of coffee or tea for an afternoon pick-me-up or packed into picnic baskets or lunch bags for a perfect little dessert.

It's really pretty easy to bake a cake. The ingredients are simple—flour, butter, sugar, and eggs. But like all good things, it takes a bit of time and attention. There are a few simple rules to follow, and I think the most important one is to take your time and avoid distraction while you're baking. Unlike making a soup or a stew, you can't leave it on the stove to simmer for a few hours and walk away. There is chemistry at work here. As for equipment, all you really need are a few roomy bowls, some cake pans, and measuring cups and spoons. A stand mixer is a good baking tool but not a necessary one. I use a hand mixer for all of my baking because while my small New York kitchen is long on experience, it is very short on space.

Here's another thing about baking cakes that seasoned baking pros and novices alike will agree on. Not all of them will be towering successes. Sometimes there is a good reason for this—your measurements were off, you used baking soda instead of baking powder (guilty), or the timing was wrong. But sometimes there is no good reason for this and you just have to shrug it off and say, "It wasn't my day to bake a cake."

Baking a cake is immensely satisfying. It's a simple pleasure that should not be taken lightly. Really, there's nothing better than to bring a lovely homemade cake to the table and say, "I made this for you."

Welcome to Cake.

Barbara Scott-Goodman

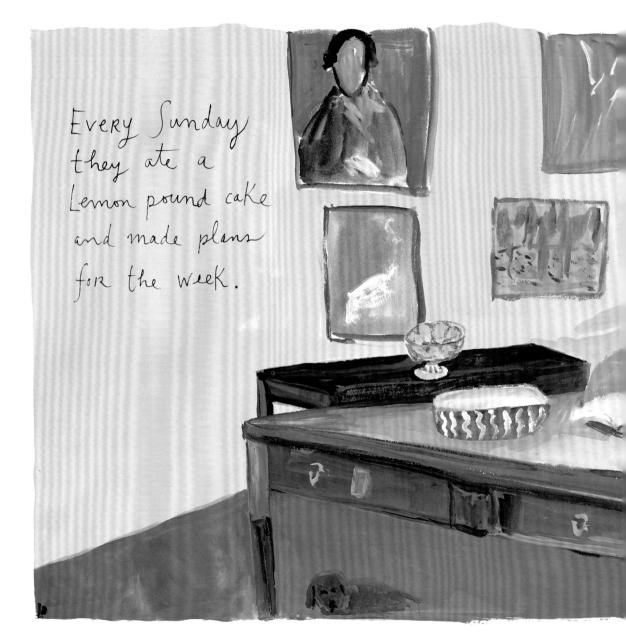

Every Sunday they ate a Lemon pound cake and made plans for the week.

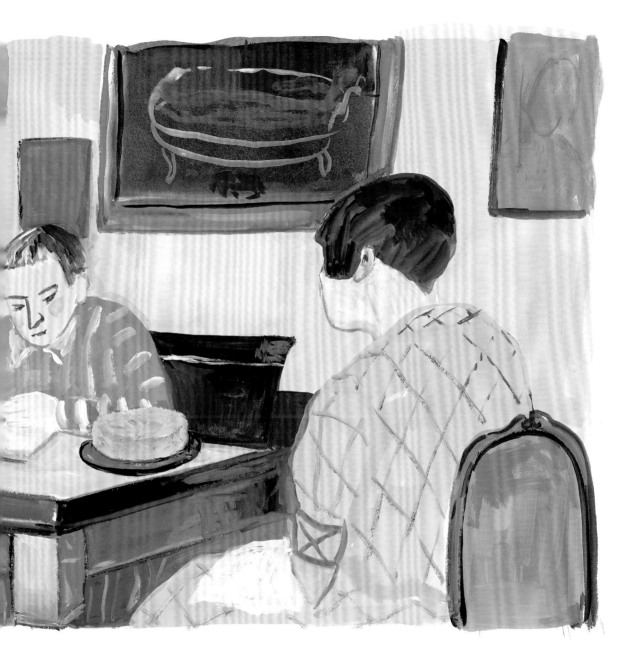

Lemon Pound Cake with Lemon Glaze

Cake

3 cups unbleached all-purpose flour

2 teaspoons baking powder

½ teaspoon salt

½ pound (2 sticks) unsalted butter, at room temperature

2 cups sugar

4 large eggs, at room temperature

1 cup whole milk

Finely grated zest of 2 lemons

Everyone needs a good lemon cake recipe in his or her baking repertoire. It's the perfect thing to serve with coffee or tea, as well as for dessert with fresh fruit, and it tastes even better after a day or two or three. Be sure to glaze the cake while it is still warm.

This is adapted from the East 62nd Street Lemon Cake recipe that is featured in the cookbook Maida Heatter's Cakes. *The cake was created by Toni Evins, Heatter's late daughter, who lived on East 62nd Street in Manhattan.*

1. Position an oven rack in the center of the oven and preheat the oven to 350°F. Butter and flour a 10-inch Bundt pan and tap out the excess flour.

2. To make the cake: Sift together the flour, baking powder, and salt and set aside.

3. In a large bowl with an electric mixer on medium speed, beat the butter until soft. Add the sugar and beat until incorporated. Beat in the eggs one at a time, scraping the bowl as needed with a spatula.

Glaze

½ cup sugar

⅓ cup fresh lemon juice

4. With the mixer on low, add the flour mixture alternately in three additions with the milk in two additions, beating only until incorporated. Stir in the lemon zest. Turn the batter into the prepared pan and gently level the top with a spatula.

5. Bake for 1 hour and 5 to 10 minutes, or until a toothpick or cake tester inserted in the cake comes out clean. Let the cake cool in the pan for 5 minutes. Run a sharp thin knife around the inside of the pan and the tube, then cover with a wire rack and invert. Lift the pan from the cake, leaving it upside down. Place the rack over a large piece of foil or wax paper and prepare the glaze.

6. To make the glaze: Mix the sugar and lemon juice together. Poke the top of the cake all over with a long wooden skewer. Pour the glaze over the top of the cake and let cool completely. It is best to wait a few hours (or even a day) before cutting the cake.

Makes one 10-inch tube cake; serves 12

Coffee Cake with Streusel

Streusel

1½ cups coarsely chopped pecans

½ cup sugar

1 tablespoon ground cinnamon

What's better than eating a slice of rich, crumbly cake with a cup of coffee? Not much, I'd say. It's a real treat to have a homemade coffee cake on hand for your family and friends, and anyone else who might drop in. This coffee cake recipe is made with a pecan streusel filling and topping that becomes slightly toasted during baking, adding a delicious, nutty crunch.

1. Position an oven rack in the center of the oven and preheat the oven to 350°F. Butter and flour a 10-inch tube pan and tap out the excess flour.

2. To make the streusel: In a small bowl, combine the pecans, sugar, and cinnamon. Set aside.

3. To make the cake: In a medium bowl, whisk the flour, baking powder, and salt together.

Cake

2¼ cups unbleached all-purpose flour

1 tablespoon baking powder

¼ teaspoon salt

1½ cups sugar

½ pound (2 sticks) unsalted butter, at room temperature

2 large eggs, at room temperature

1½ cups sour cream

1 tablespoon vanilla extract

4. In a large bowl with an electric mixer on high speed, beat the sugar and butter until light and fluffy, about 3 minutes. Add the eggs one at a time, beating well after each addition. Beat in the sour cream and vanilla. With the mixer on low, add the flour mixture in thirds, beating until just smooth and scraping down the sides of the bowl as needed. Do not overbeat.

5. Spread half of the batter in the prepared pan. Sprinkle with half of the streusel mixture. Top with the remaining batter and smooth the top. Sprinkle the remaining streusel mixture over the batter.

6. Bake for about 1 hour, or until a toothpick or cake tester inserted in the cake comes out clean. Let it cool on a wire rack for 10 minutes. Run the tip of a sharp knife around the inside of the pan and the tube to loosen it. Invert the cake, unmold onto the rack, and turn right side up. Serve warm or at room temperature.

Makes one 10-inch tube cake; serves 10 to 12

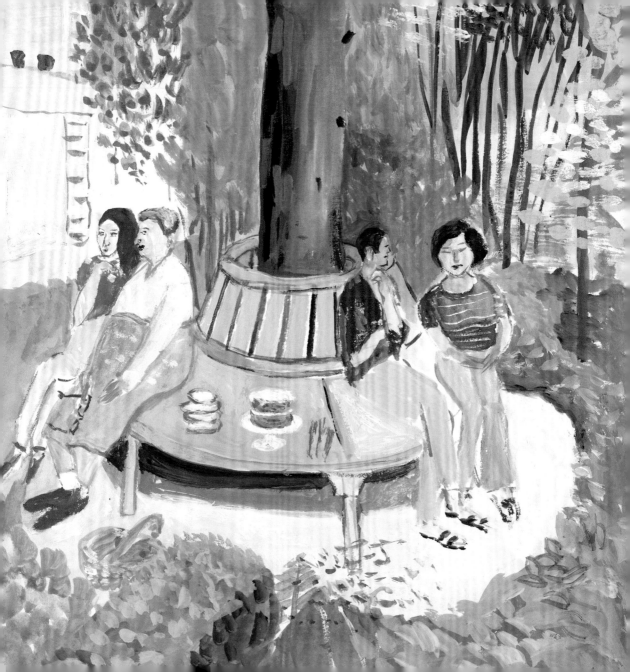

Carrot Cake
with Cream Cheese Frosting

Cake

2 cups unbleached all-purpose flour

2 teaspoons baking soda

1½ cups vegetable oil

2 cups sugar

4 large eggs, at room temperature

1 tablespoon ground cinnamon

½ teaspoon ground ginger

¼ teaspoon ground cloves

1 teaspoon salt

3 cups finely grated carrots (about 4 large carrots)

1½ cups pecans, toasted and chopped

1 cup golden raisins (optional)

When we think of carrot cake, we often think of dense "back-to-the-earth" concoctions that are loaded with raisins, pineapple, and coconut. This version is much lighter and is made with fresh carrots, spices, and toasted pecans. If you insist on adding raisins, use golden ones.

In the South, carrot cake is sometimes called Queen Anne's Cake, named after Queen Anne's lace, which is a wild carrot plant. It's a nice idea to take a pause in the day and have a slice of cake with coffee or tea (hot or iced), like many southerners do.

1. Position an oven rack in the center of the oven and preheat the oven to 350°F. Lightly butter two 9-inch round cake pans and line the bottoms with parchment paper.

2. To make the cake: In a medium bowl, mix the flour and baking soda together and set aside.

Frosting

¼ pound (1 stick) unsalted
butter, at room temperature

One 8-ounce package cream
cheese, at room temperature

1½ cups confectioners' sugar

2 teaspoons vanilla extract

Pinch salt

2 tablespoons grated lemon
zest, for garnish

3. In a large bowl with an electric mixer on medium speed, beat the oil, sugar, eggs, cinnamon, ginger, cloves, and salt together until smooth. Add the flour mixture and stir until smooth. Add the grated carrots, pecans, and raisins, if using, and stir until just blended. Spoon the batter into the prepared pans.

4. Bake the cakes for 35 to 40 minutes, or until a toothpick or a cake tester inserted in the center of the cakes comes out clean. Run a thin knife around the insides of the pans to release the cakes. Invert them onto wire racks, peel off the paper, and let cool, right side up.

5. To make the frosting: In a large bowl with an electric mixer on medium speed, beat the butter and cream cheese together until smooth. Add the sugar, vanilla, and salt and beat until very smooth.

6. Put one cake layer on a serving plate and spread some of the frosting over the top. Put the second cake layer, flat side down, on top and frost the top. Refrigerate until serving.

7. Sprinkle the top of the cake with the lemon zest, cut into slices, and serve.

Makes one 9-inch 2-layer cake; serves 12

Notes

You will save a lot of time and effort if you grate the carrots in a food processor with a grating attachment instead of using a hand grater.

The key to the fluffy frosting here is to make sure that the butter and cream cheese are at room temperature when you whip them together.

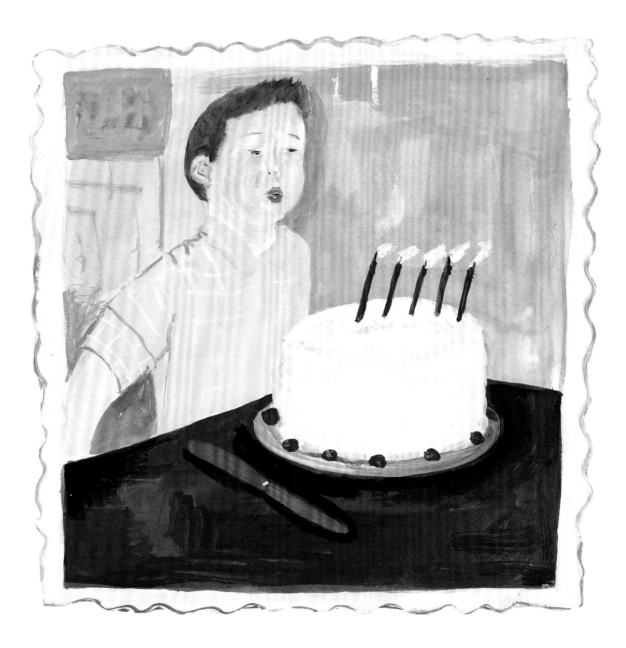

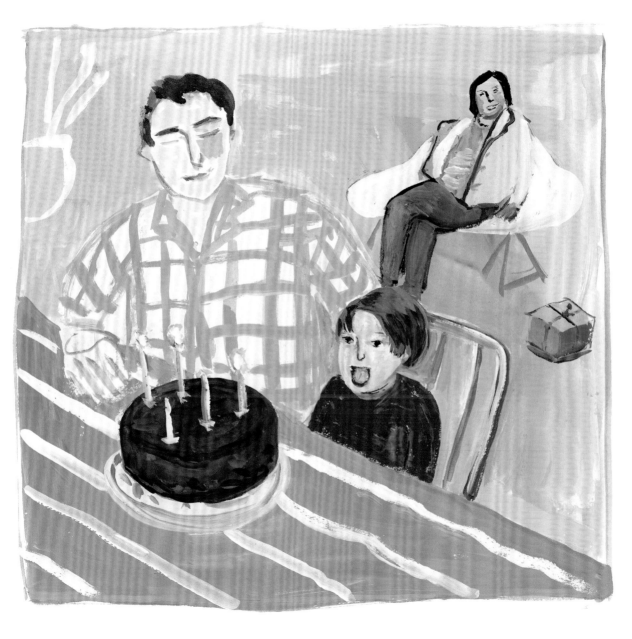

Chocolate Layer Cake with Chocolate Frosting

Cake

1 cup boiling water

¾ cup unsweetened cocoa powder

1¾ cups unbleached all-purpose flour

1½ teaspoons baking soda

¼ teaspoon salt

2 cups sugar

10 tablespoons (1¼ sticks) unsalted butter, at room temperature

3 large eggs, at room temperature

1 teaspoon vanilla extract

1¼ cups buttermilk

January 27 is National Chocolate Cake Day, but really any day is a good one to make this time-honored classic chocolate layer cake.

1. Position an oven rack in the center of the oven and preheat the oven to 350°F. Butter two 9-inch round cake pans and line the bottoms with parchment paper. Dust with flour and tap out the excess.

2. To make the cake: In a small heatproof bowl, whisk together the boiling water and cocoa until smooth. Set aside.

3. Sift the flour, baking soda, and salt into a medium bowl. In a large bowl with an electric mixer on medium speed, beat the sugar and butter together until light. Add the eggs one at a time, beating well after each addition. Beat in the vanilla and the cocoa mixture.

Frosting

3¾ cups confectioners' sugar

1 cup unsweetened cocoa powder

¼ pound (1 stick) unsalted butter, at room temperature

1 teaspoon vanilla extract

About 1 cup heavy cream

4. With the mixer on low, add the flour mixture alternately with the buttermilk, ending with the dry ingredients, beating until smooth. Divide the batter evenly between the prepared pans and smooth the tops.

5. Bake the cakes for 35 to 40 minutes, or until a toothpick or cake tester inserted in the center of the cakes comes out clean. Transfer the cakes to wire racks and let cool in the pans for 10 minutes. Loosen the cakes carefully from their pans with a knife and invert onto the racks. Peel off the paper. Turn the cakes right side up and let cool to room temperature.

6. To make the frosting: Sift the confectioners' sugar and cocoa into a large bowl. With an electric mixer on low speed, mix in the butter. Add the vanilla and gradually mix in enough of the cream to make a spreadable frosting.

7. Transfer one cake layer to a serving plate and spread the top with a small amount of frosting. Top with the other layer and frost the sides and the top, swirling the frosting. Let the cake stand for at least 30 minutes before cutting.

Makes one 9-inch 2-layer cake; serves 8 to 10

Flourless Chocolate Cake

Cake

½ pound semisweet chocolate, coarsely chopped

¼ pound (1 stick) unsalted butter, at room temperature, cut into pieces

6 large eggs, 2 whole, 4 separated, at room temperature

1 cup sugar

This elegant flourless cake is a chocolate lover's dream. Be sure to use the best-quality semisweet chocolate and the freshest eggs that you can find when making it. Let the cake cool in the springform pan and fill it mit schlag *(with whipped cream) before serving.*

1. Position an oven rack in the center of the oven and preheat the oven to 350°F. Line the bottom of an 8-inch springform pan with a round of parchment paper; do not butter the pan. Set the pan on a large sheet of aluminum foil and fold up the edges around it.

2. To make the cake: Melt the chocolate and butter in a heatproof bowl set over hot water. When completely melted, stir the mixture together and set aside to cool a bit.

3. In a large bowl, whisk the 2 whole eggs and the 4 egg yolks with ½ cup of the sugar until well blended. Whisk in the chocolate mixture.

Whipped cream

1½ cups cold heavy cream

1 teaspoon vanilla extract

Unsweetened cocoa powder, for sprinkling

4. In another large bowl with an electric mixer on medium-high speed, beat the 4 egg whites until foamy. Gradually add the remaining ½ cup sugar and beat until the whites form soft mounds that hold their shape but are not quite stiff. Stir about one quarter of the beaten egg whites into the chocolate mixture to lighten it, then gently fold in the remaining whites. Pour the batter into the pan and smooth the top.

5. Bake for 35 to 40 minutes, or until the top of the cake is puffed and cracked and the center is no longer wobbly. Do not overbake. Cool the cake completely in the pan on a wire rack. The cake will sink as it cools.

6. To make the whipped cream: Just before serving, whip the cream with the vanilla until not quite stiff. With a spatula, carefully fill the inside of the cake with the whipped cream, pushing it gently to the edges. Dust the top lightly with cocoa powder. Run the tip of a knife around the edges of the cake, carefully remove the sides of the pan, and serve.

Makes one 8-inch cake; serves 8 to 12

Mit Schlag

Mit schlag *simply means "with whipped cream," and it is the perfect, rich, not-too-sweet accent to many cakes. As a topping for coffee or hot chocolate, it is generally served unsweetened. If it is made to serve with cake or other desserts, sugar and vanilla are usually added.*

Basic Whipped Cream

Here is a good recipe for basic whipped cream. Be sure not to overwhip the cream; you want it to have a light and fluffy texture.

1 cup cold heavy cream

2 tablespoons sugar

1 teaspoon vanilla extract

In a medium bowl with an electric mixer on high speed, whip the cream, sugar, and vanilla just until stiff peaks begin to form. If not using the cream right away, cover with plastic wrap and refrigerate until ready to serve, or up to 1 day. If the cream separates, whisk again to the proper consistency.

Makes about 2 cups

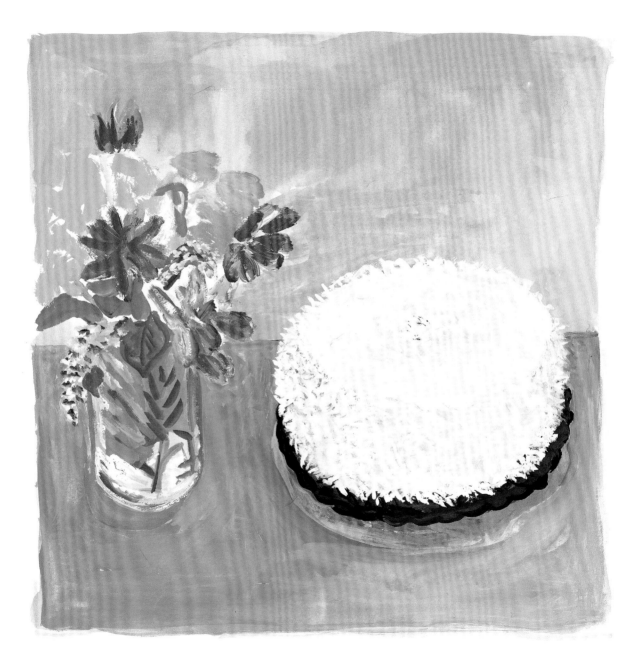

Coconut Layer Cake

Cake

3 cups cake flour (not self-rising)

2½ cups sugar

1½ tablespoons baking powder

½ teaspoon salt

5 large egg whites

½ cup whole milk

1 tablespoon coconut extract

½ pound (2 sticks) salted butter, at room temperature

1 cup unsweetened coconut milk

This beautiful layer cake is the one to serve for special birthdays and dinner parties. The key ingredients that make the cake so incredibly light and moist are cake flour and lightly beaten egg whites. To finish the cake, toast half of the shredded coconut to give it a nice, nutty flavor.

1. Position an oven rack in the center of the oven and preheat the oven to 350°F. Butter and flour two 9-inch round cake pans and line them with parchment paper.

2. To make the cake: In a large bowl, whisk together the flour, sugar, baking powder, and salt and set aside. In another bowl, whisk together the egg whites, milk, and coconut extract and set aside.

3. In a large bowl with an electric mixer on low speed, beat the butter and coconut milk until blended. Increase the speed to medium and beat for about 2 minutes, until light and fluffy, scraping down the sides of the bowl as needed.

2 cups unsweetened shredded
coconut

½ pound cream cheese, at room
temperature

¼ pound (1 stick) salted butter,
at room temperature

1 teaspoon vanilla extract

1½ to 2 cups confectioners'
sugar

4. Add the flour mixture and beat until incorporated. Add the egg white mixture in 3 additions, scraping down the sides of the bowl and mixing just long enough to incorporate after each addition.

5. Spoon the batter evenly into the prepared pans and smooth the tops with a spatula. Bake for 35 to 40 minutes, or until a toothpick or cake tester inserted into the center of the cakes comes out clean. Remove the cakes and allow them to cool in their pans for 10 minutes, then turn them out onto wire racks to cool completely. Peel off the paper.

6. To toast the coconut: Preheat the oven to 350°F. Spread half of the shredded coconut on a baking sheet and toast it for 7 to 10 minutes, until golden. Watch it carefully, as it can burn quickly. Let cool completely, and mix together with the remaining coconut.

7. To make the frosting: In a large bowl, with an electric mixer on low speed, beat the cream cheese, butter, and vanilla. Add the confectioners' sugar and mix until smooth.

8. To assemble the cake, transfer one layer flat to a serving plate, upside down, and spread with frosting and sprinkle with some of the coconut. Put the second layer on top, right side up, and frost the top and the sides of the cake. Scatter some of the coconut mixture evenly over the top of the cake. Press the remaining coconut onto the sides. Serve at room temperature.

Makes one 9-inch 2-layer cake; serves 8 to 10

Variations

Instead of spreading the center layer of the cake with frosting you can use another delicious ingredient like raspberry, strawberry, or blueberry preserves, or lemon curd. Be sure to sprinkle the top of the layer with coconut.

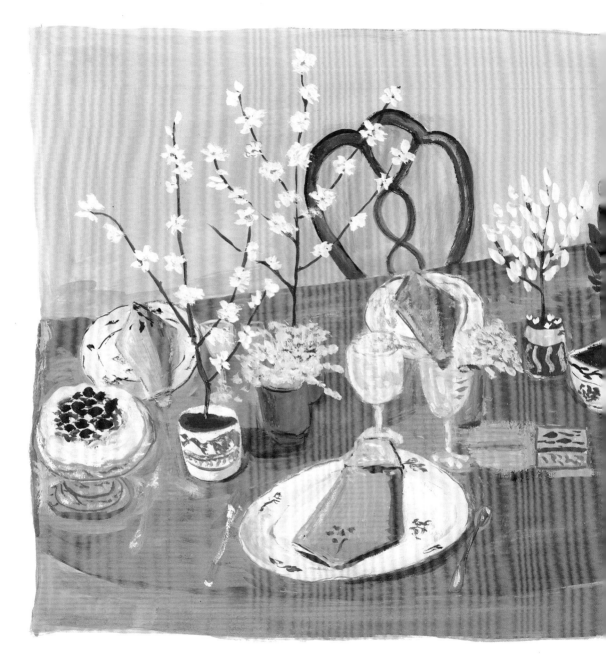

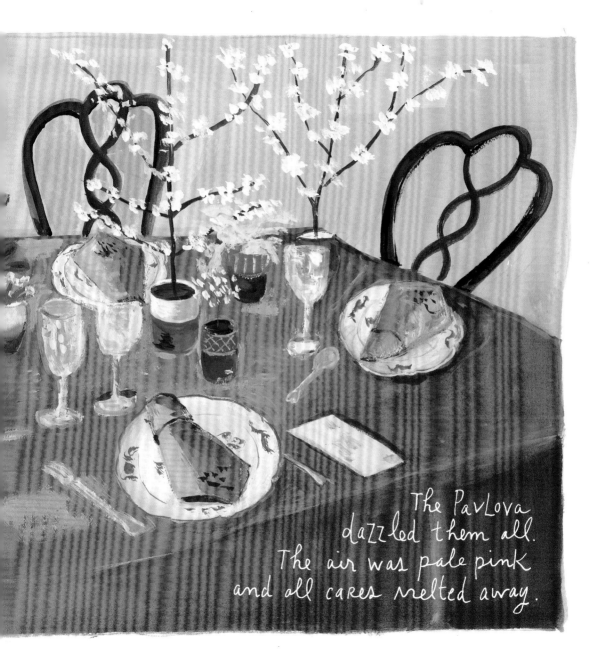

The Pavlova
dazzled them all.
The air was pale pink
and all cares melted away.

Pavlova with Fresh Berries

Pavlova

4 extra-large egg whites,
 at room temperature

Pinch kosher salt

1 cup sugar

2 teaspoons cornstarch

1 teaspoon white wine vinegar

½ teaspoon vanilla extract

Pavlova, the elegant dessert named after the Russian prima ballerina Anna Pavlova, is a meringue-based confection that is topped with whipped cream and fresh fruit.

There has always been a bit of controversy about the origins of this ethereal dessert. It is said that Anna Matveyevna Pavlova's dance company was the first to tour the world, and they performed in Australia and New Zealand in 1926. Her visit to New Zealand was considered "the chief event of 1926." To this day, both countries claim credit for the invention of the Pavlova.

Pavlova is often finished with a mix of fruit that includes kiwis, passion fruit, and strawberries. But to my taste, it is best served in early summer with fresh seasonal berries from the greenmarket. Our good friend Susan Kramer makes a superb Pavlova, and she swears by using thimble-sized, intensely sweet Tristar strawberries.

1. Preheat the oven to 350°F. Line a baking sheet with parchment paper. Draw a circle on the paper using a 9-inch round plate or cake pan as a guide.

Berries

1/2 pint fresh strawberries, hulled and sliced

1/2 pint fresh blueberries

1/2 pint fresh raspberries

2 teaspoons superfine sugar

2. In a large bowl with an electric mixer on high speed, beat the egg whites until firm, 1 to 2 minutes. With the mixer still on high, slowly add the sugar and beat until the meringue is firm and glossy.

3. Sprinkle in the cornstarch, vinegar, and vanilla and fold in lightly with a rubber spatula. Pile the meringue into the middle of the circle on the parchment paper and, using a knife, smooth it within the circle, making a rough disk.

4. Slide the pan into the oven and reduce the heat immediately to 300°F. Bake for 1 hour and 15 minutes. Turn off the oven, keep the door closed, and allow the meringue to cool completely in the oven, about 1/2 hour to 1 hour, making sure that it doesn't get too brown. It will be crisp on the outside and soft on the inside.

5. One hour before serving, combine the strawberries, blueberries, and raspberries in a bowl, sprinkle with sugar, and let the berries macerate. Stir occasionally.

Whipped cream

1 cup cold heavy cream

1 tablespoon sugar

1 teaspoon vanilla extract

6. To make the whipped cream: In a large bowl with an electric mixer on medium-high speed, whip the cream until it just begins to thicken. Add the sugar and vanilla and continue to beat until firm.

7. To serve, peel the parchment paper off the meringue and transfer to a cake plate or stand. Spread the whipped cream over the top and spoon the berries over the whipped cream, allowing the juices to drizzle down the sides. Serve immediately.

Makes one 9-inch Pavlova; serves 6 to 8

Variations

Here are some other good fruit combinations for a Pavlova (no maceration necessary):

> *Nectarines, blueberries, kiwis*
> *Peaches, plums, blackberries*
> *Mangoes, bananas, oranges*
> *Apples, pears, grapes, dried cranberries*

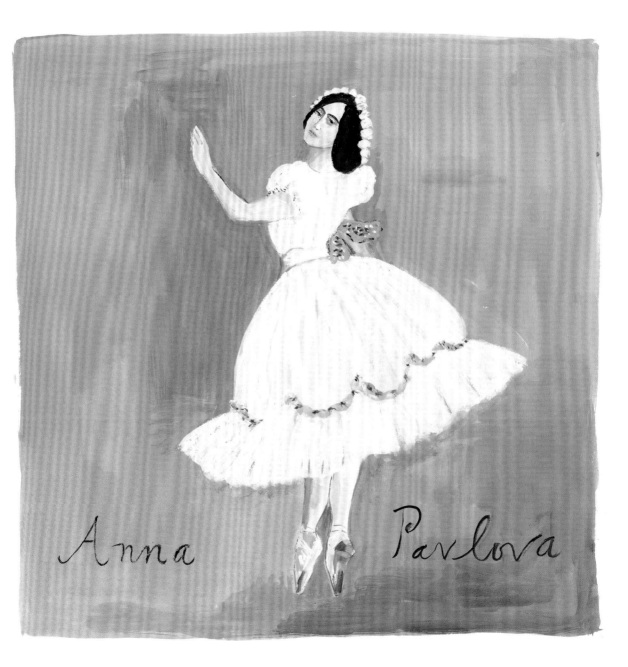

Anna Pavlova

The Broken Heart Cake

When I was sixteen, my heart was broken by Michael Goldenthal. He was leaving for College. I was left behind. The truth was, he was always an unwilling participant in our Romance. I did more stalking than actual dating. But LOVE is LOVE, and I was despondent. Shoshana was staying with us in our AIRY apartment in the BRONX. The one down the block from Mother's Bakery. Shoshana, seeing my SORROW, Rather feeling my SORROW, offered to make me a CAKE. Something sweet to soothe my soul. But I Rejected her offer with a dismissive wave of the hand. What can a chocolate cake do in the face of a Broken heart? Well, I was stupid of course.
 She was offering me LOVE. Oh, stupid youth.

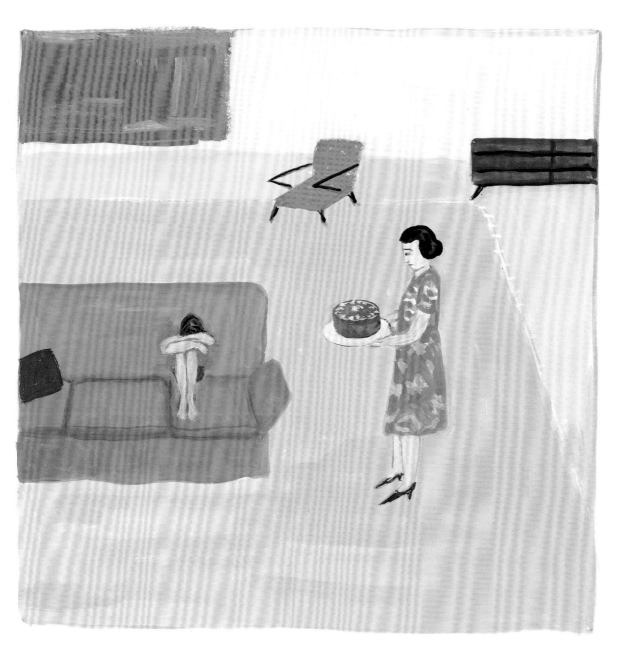

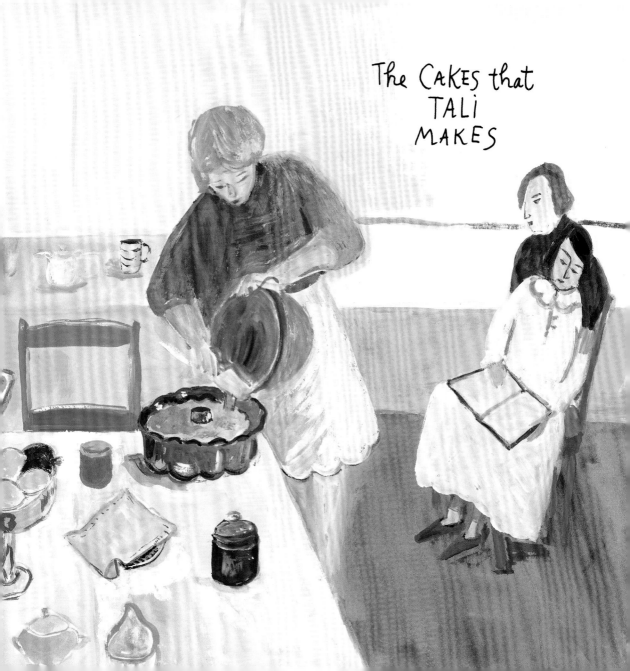

The CAKES that TALI MAKES

TALi makes CAKES foR EVERYONE in the family.

If you aRRive, theRe is a cake waiting foR you.

If you Leave, a CAKe is made to accompany you home.

You aRe NeveR aLONe.

Tali is always with you.

A cake is always with you.

The Philosophical Cake

When we lived in Rome we had a
party and we made a gorgeous pink cake.
Lucretius was on our mind. And Spinoza.
His search for happiness. And someone
mentioned Nietzsche's quote. He said
a day without dancing is a wasted
day. You don't think of philosophers
dancing, especially Nietzsche.
But apparently they do.

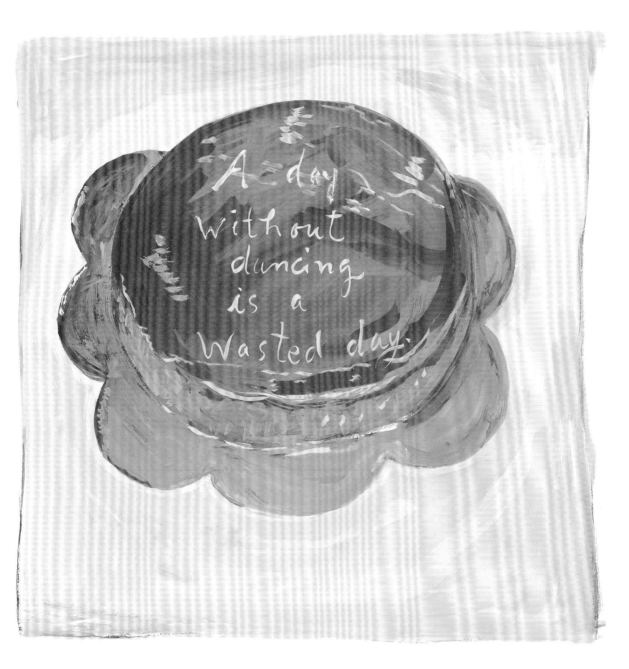

The Talking Cure Cake

Now on the terrace we sit at the table
and talk. And talk and talk.
About relatives who are idiots. Or relatives who
are better than we knew. What trips we are
planning. What burdens we bear.
And always there is a cake. If you go to visit
an elderly aunt in a crisp dress (who earlier had
hauled the wet laundry up to the roof to hang
and dry), she will serve you cake that she
made at dawn. No doubt about that.
Cheesecake or honey cake or fruitcake.
Then you can tell her your troubles and
she will offer sage advice. Usually. But not
always. She is human, after all.

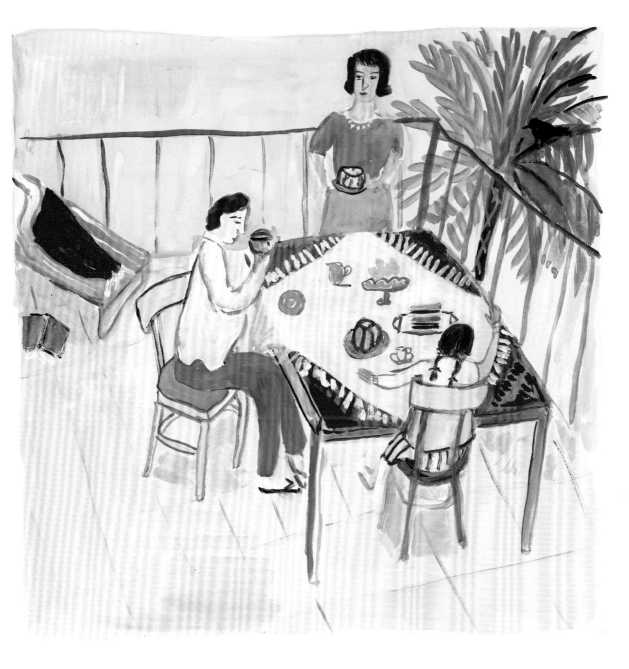

Strawberry and Blueberry Shortcakes

Shortcakes

4 cups unbleached all-purpose flour, plus more for rolling the dough

3 tablespoons sugar

¼ teaspoon salt

5 teaspoons baking powder

6 ounces (1½ sticks), plus 2 tablespoons unsalted butter, at room temperature

1¼ cups heavy cream

There is no better way to celebrate summer than to serve shortcakes slathered with whipped cream and piled high with fresh berries. These individual shortcakes are baked together as two round layers, then split and filled with fresh strawberries, blueberries, and whipped cream. If you can't serve them as soon as they come out of the oven, warm the shortcakes up a bit before adding the berries and cream.

1. Position an oven rack in the center of the oven and preheat the oven to 450°F. Butter a baking sheet and set aside.

2. To make the shortcakes: Sift the flour, sugar, salt, and baking powder into a large bowl. Add 6 ounces of the butter and work into the dry ingredients using your fingers or a pastry blender. Add the cream and mix into a soft dough. Knead the dough for about 1 minute or until it holds together.

3. Transfer to a lightly floured pastry board or a large sheet of wax paper and, using a floured rolling pin, roll it out to a rectangle about ½ inch thick.

Berries

2 pints fresh ripe strawberries

1 pint ripe blueberries

½ cup sugar, or more to taste

Whipped cream

2 cups cold heavy cream

1 teaspoon white rum

½ teaspoon vanilla extract

4. Using a floured 3-inch biscuit cutter, cut out as many rounds as you can. Press the scraps together, roll out again, and cut out to make 16 rounds. Transfer 8 of the rounds to the baking sheet. Melt the remaining 2 tablespoons of butter in a small saucepan and brush the tops. Place the remaining 8 rounds on top of them. Bake for about 15 minutes, until the tops of the biscuits are golden brown.

5. For the berries: Meanwhile, hull the strawberries, slice them in half, and put them in a large shallow bowl. Add the blueberries and stir in the sugar. Toss together gently, cover, and set aside for about 30 minutes (see Notes).

6. To make the whipped cream: In a large bowl with an electric mixer on medium high speed, whip the cream until it just begins to thicken, add the rum and vanilla and beat until firm. If not serving right away, the whipped cream can be chilled in the refrigerator for up to 1 hour.

7. To serve, pull the shortcakes apart and arrange the bottoms on small cake plates. Spoon some of the whipped cream and a generous amount of the berries over them. Top them with the shortcake tops, the remaining whipped cream and berries, and serve.

Makes 8 shortcakes; serves 8

Notes

If you are not serving the shortcakes right away, prepare the berries no more than half an hour before serving so they don't get mushy.

The shortcakes can also be frozen, but they should be warmed before serving.

Variations

Shortcakes can also be served with fresh peaches and/or raspberries.

Yellow Layer Cake with Salt Caramel Glaze

Cake

2½ cups cake flour
 (not self-rising)

1 teaspoon baking powder

½ teaspoon baking soda

1 teaspoon salt

2 cups sugar

½ pound (2 sticks) salted butter,
 at room temperature

3 large eggs plus 3 egg yolks,
 at room temperature

1 cup buttermilk

1 tablespoon vanilla extract

Every baker needs a sure-fire recipe for a traditional yellow layer cake because it is a perennial favorite and perfect for all kinds of parties. And while it is delicious with white or chocolate frosting, it is absolutely fantastic when its layers are drizzled with salt caramel glaze. Be sure to use cake flour, not the self-rising type, when baking this cake.

1. Position an oven rack in the center of the oven and preheat the oven to 350°F. Butter two 9-inch round cake pans and line the bottoms with parchment paper. Dust with flour and tap out the excess.

1 cup sugar

½ cup water

A few drops fresh lemon juice

6 tablespoons (¾ stick) salted butter, at room temperature, cut into pieces

6 tablespoons heavy cream

¼ teaspoon kosher salt

½ teaspoon vanilla extract

Sea salt or kosher salt, for sprinkling (optional)

2. To make the cake: Sift the flour, baking powder, baking soda, and salt into a medium bowl. In a large bowl with an electric mixer on high speed, beat the sugar and butter until light and fluffy, about 3 minutes. Beat in the eggs and the yolks one at a time, scraping down the sides of the bowl as needed. With the mixer on low speed, beat in the flour mixture, alternating with the buttermilk and beating until smooth. Add the vanilla and beat again, scraping down the sides of the bowl as needed. Divide the batter between the prepared pans and smooth the tops.

3. Bake for 30 to 35 minutes, or until a toothpick or cake tester inserted in the center of the cakes comes out clean.

4. Transfer the cakes to wire racks and let cool in the pans for 10 minutes. Loosen the cakes carefully from their pans with a knife and invert onto the racks. Peel off the paper. Turn the cakes right side up and let cool to room temperature.

5. To make the glaze: Stir the sugar, water, and lemon juice together in a medium saucepan and cook over medium heat until the sugar turns deep amber brown and just starts to smoke, tilting the pan gently as the sugar cooks, about 8 to 10 minutes.

6. Remove from heat and stir in the butter until melted, then stir in the heavy cream, salt, and vanilla until smooth. Let the glaze cool until it's just slightly warm.

7. To assemble the cake, put one cake layer, flat side up, on a serving plate. Spoon half of the glaze over the cake, letting it drizzle down the sides of the cake. Sprinkle with a bit of salt, if desired. Add the second cake layer, flat side down, on top. Spoon the remaining glaze on top of the cake and let it drizzle down the sides of the cake. Sprinkle the top of the cake with a bit more salt, if desired.

Makes one 9-inch 2-layer cake; serves 10 to 12

Cake Flour

Cake flour is a type of fine wheat flour with a very low protein content. It's best for cakes that need a light taste and moist texture, like white and yellow cakes. It is often so finely ground that it resembles confectioners' sugar. Like all flours, it should be stored in an airtight container and used within a year.

Don't confuse cake flour with self-rising flour, which is all-purpose flour with baking powder or other leavening agents added to it.

Is there anyone who does not love cheesecake? Impossible.

Cheesecake

Crust

1¼ cups graham cracker crumbs

6 tablespoons (¾ stick) unsalted butter, melted

⅓ cup sugar

Even though there is a pound of cream cheese in this recipe, this is a very light cheesecake, much less dense than most. It can be made any time of year, but I think of it as a summer dessert and often serve it with blueberry sauce or top it with fresh peaches or strawberries (or both). The cake will rise quite high before falling a bit, which means that you can't open the oven to take a peek while it is baking.

1. Position an oven rack in the center of the oven and preheat the oven to 350°F. Butter a 9-inch springform pan. Set the pan on a large sheet of aluminum foil and fold up the edges around it.

2. To make the crust: Put the crumbs in a medium bowl, add the butter and sugar, and blend well. Using the bottom of a measuring cup or the smooth bottom of a glass, press the crumb mixture onto the base of the pan and 1 inch up the sides. Smooth the crumbs along the base for an even thickness.

3. Bake the crust for 10 minutes. Remove and let cool completely.

1 pound (two 8-ounce packages) cream cheese, at room temperature

½ cup sugar

2 tablespoons unbleached all-purpose flour

1 teaspoon vanilla extract

1 tablespoon grated lemon zest

1 tablespoon fresh lemon juice

4 large eggs, separated

½ cup heavy cream

4. To make the filling: Reduce the heat to 325°F. In a large bowl with an electric mixer on medium speed, beat the cream cheese and sugar together until fluffy, 3 to 5 minutes. Add the flour, vanilla, lemon zest, and lemon juice and continue beating. Add the egg yolks one at a time, beating thoroughly after each addition. Add the cream and mix well.

5. In another large bowl, beat the egg whites until they are stiff. Gently fold them into the cream cheese mixture.

6. Pour the mixture into the prepared crust and bake for about 1 hour and 15 minutes, until the center is firm. Do not open the oven door while baking! Cool the cheesecake to room temperature on a rack. Chill in the refrigerator, loosely covered, for at least 4 hours.

7. To serve, loosen the cheesecake from the sides of the pan by running a thin knife around the inside rim. Remove the sides of the pan and transfer the cake to a serving plate. Slice the cheesecake with a thin, nonserrated knife that has been dipped in warm water, wiping the knife dry after each cut.

Makes one 9-inch cake; serves 8 to 10

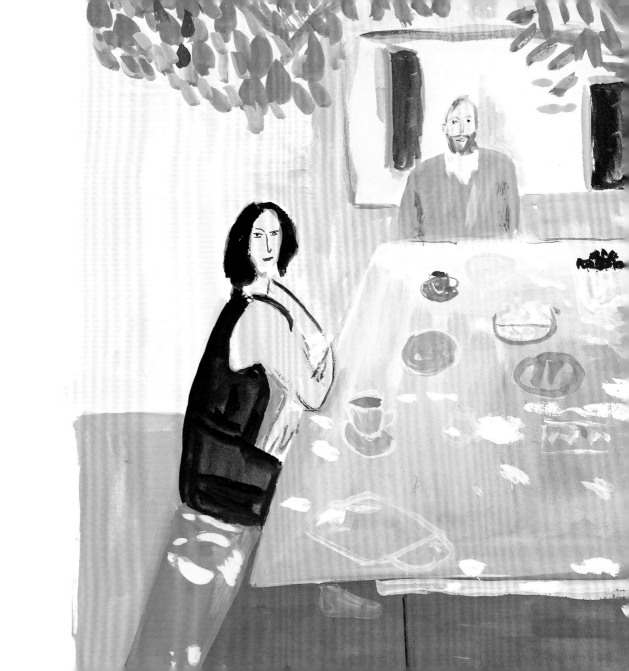

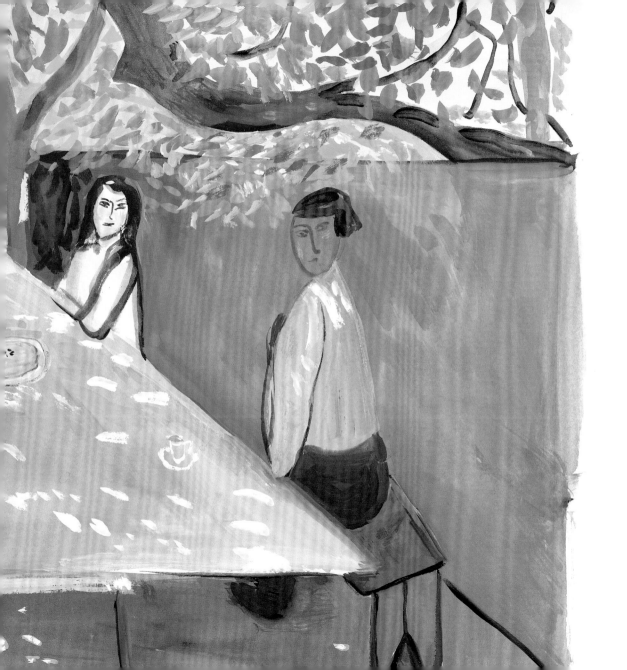

Pistachio and Almond Pound Cake

Cake

¾ cup shelled pistachios

¼ cup blanched slivered almonds

1½ cups unbleached all-purpose flour

½ teaspoon baking powder

¾ teaspoon salt

6 ounces (1½ sticks) unsalted butter, at room temperature

1¼ cups sugar

3 large eggs, at room temperature

½ teaspoon vanilla extract

½ cup whole milk

This is a classic pound cake recipe with a rich addition of ground pistachios and almonds. I like to serve it with a big dollop of whipped cream. You can also garnish the cake with seasonal fruit like fresh spring strawberries or juicy, ripe summer peaches.

1. Position an oven rack in the center of the oven and preheat the oven to 325°F. Lightly butter and flour a 9 x 5 x 3-inch loaf pan and tap out the excess flour.

2. To make the cake: In a food processor, grind the pistachios and almonds until they resemble flour. Add the flour, baking powder, and salt, and pulse until combined.

3. In a large bowl with an electric mixer on medium-high speed, beat the butter until smooth. Slowly add the sugar and beat until very light and fluffy. Add the eggs, one at a time, beating well after each addition and scraping down the sides of the bowl. Add the vanilla and beat again.

1 cup cold heavy cream

1 tablespoon sugar

1 teaspoon vanilla extract

4. With the mixer on low speed, add the flour mixture alternately in three additions with the milk in two additions until incorporated after each addition.

5. Pour the batter into the prepared pan and bake for 1 hour and 10 minutes, or until a toothpick or cake tester inserted into the center of the cake comes out clean. Cool the cake in the pan for 15 minutes then transfer to a rack to cool completely.

6. To make the whipped cream: In a large bowl with an electric mixer on medium-high speed, whip the cream until it just begins to thicken. Add the sugar and vanilla, and continue to beat until firm.

7. Serve the cake warm or at room temperature with the whipped cream.

Makes one 9 x 5-inch loaf cake; serves 6 to 8

Olive Oil Cake

1¼ cups olive oil, plus oil for the pan

2 cups unbleached all-purpose flour

1¾ cups sugar

1½ teaspoons kosher salt

½ teaspoon baking soda

½ teaspoon baking powder

1¼ cups whole milk

3 large eggs, at room temperature

2 teaspoons grated orange zest

¼ cup fresh orange juice

¼ cup Grand Marnier

Rich and aromatic olive oil cake is a classic and there are many versions of it. The cake is a snap to make and there is no need to use a mixer or food processor. It's simply a blend of flour, sugar, and other dry ingredients whisked together with eggs and olive oil. It can be made with regular or extra-virgin olive oil and flavored with orange and lemon. This recipe, made with orange juice, orange zest, and Grand Marnier, is adapted from Maialino, the lovely restaurant on Gramercy Park in New York. Plan to make it ahead of time—because it tastes great and a little boozy after two or three days.

1. Position an oven rack in the center of the oven and preheat the oven to 350°F. Oil a 9-inch round cake pan that is at least 2 inches deep and line the bottom with parchment paper.

2. In a medium bowl, whisk the flour, sugar, salt, baking soda, and baking powder together. In a large mixing bowl, whisk the olive oil, milk, eggs, orange zest, orange juice, and Grand Marnier together. Add the flour mixture and whisk until just combined. The batter will be a bit thin.

3. Pour the batter into the prepared pan and bake for 55 minutes to 1 hour, or until the top is golden and a toothpick or cake tester inserted in the center of the cake comes out clean. Transfer the cake to a wire rack and let cool for 30 minutes.

4. Run a sharp thin knife around the edges of the pan, invert the cake onto the rack, peel off the paper, and let cool completely.

Makes one 9-inch cake; serves 10 to 12

Honey Cake

3½ cups unbleached all-purpose flour

1 tablespoon baking powder

1 teaspoon baking soda

½ teaspoon salt

4 teaspoons ground cinnamon

½ teaspoon ground cloves

½ teaspoon ground allspice

1 cup vegetable oil

1 cup honey

1½ cups sugar

½ cup packed brown sugar

3 large eggs, at room temperature

1 teaspoon vanilla extract

1 cup warm coffee or strong tea

½ cup fresh orange juice

¼ cup rye or whiskey

Honey cake is a traditional dessert that is served on Rosh Hoshana. The cake should always be very moist and sweet, as good on the day of baking as it is days later. Here is the Majestic and Moist Honey Cake from Marcy Goldman's cookbook, A Treasury of Jewish Holiday Baking. *It is the sine qua non recipe for this iconic cake.*

1. Position an oven rack in the center of the oven and preheat the oven to 350°F. Lightly grease a 9-inch angel food cake pan or a 10-inch tube pan. Cut a circle of parchment paper to fit the bottom of the pan, lightly grease it, and line the pan.

2. In a large bowl, whisk together the flour, baking powder, baking soda, salt, and spices. Make a well in the center and add the oil, honey, sugars, eggs, vanilla, coffee, orange juice, and rye.

3. Using a strong wire whisk or an electric mixer on low speed, beat the ingredients well to make a thick batter, making sure that no dry ingredients remain in the bottom of the bowl.

4. Spoon the batter into the prepared pan.

5. Put the cake pan on two baking sheets stacked together and bake 60 to 70 minutes, or until the cake springs back when you touch it gently in the center. This is a thin batter and, depending on your oven, it may need extra time.

6. Let the cake stand for 15 minutes before removing it from the pan. Run the tip of a sharp knife around the inside of the pan and the tube to loosen it. Invert the cake onto a wire rack to cool completely.

Makes one 9- or 10-inch cake; serves 8 to 10

Everything she said was hilarious.

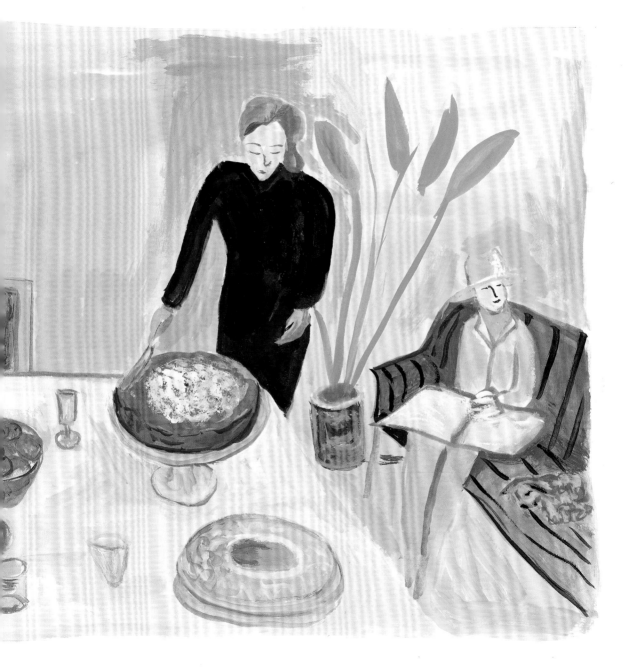

Plum Torte

¼ pound (1 stick) unsalted butter, at room temperature

¾ cup sugar, plus more for sprinkling

1 cup unbleached all-purpose flour

1 teaspoon baking powder

Pinch salt (optional)

2 large eggs, at room temperature

12 purple plums, halved and pitted (see Variations)

Fresh lemon juice, for sprinkling

1 teaspoon ground cinnamon

Whipped cream, for serving (optional)

This recipe is adapted from the one that was created and written by food writer Marian Burros. It first appeared in The New York Times *in 1983 and it remains the most requested recipe that the paper has ever printed. It's easy to see why—it's delicious, easy to make, and incredibly versatile, since it can be made with all kinds of fruit other than the blue-black Italian plums that the original recipe calls for.*

This ubiquitous torte shows up on tables year-round—for winter holiday meals as well as at picnics and barbecues in the summer. It's a real keeper.

1. Position an oven rack in the center of the oven and preheat the oven to 350°F. Set a 9-inch springform pan on a large sheet of aluminum foil and fold up the edges around it.

2. In a large bowl with an electric mixer on medium speed, beat the butter and sugar together. Add the flour, baking powder, salt, if using, and eggs and beat well.

3. Spoon the batter into the pan. Arrange the plum halves, skin side up, on top of the batter. Sprinkle lightly with sugar and lemon juice. Sprinkle with the cinnamon.

4. Bake for 1 hour. Remove the torte and let cool. Run the tip of a knife around the edges of the cake and carefully remove the sides of the pan. Serve plain or with whipped cream.

Makes one 9-inch torte; serves 8

Variations

You can make this torte with almost any seasonal fruit, such as apricots in the late spring; berries, peaches, and nectarines in the summer; apples, pears, and figs in the fall; and fresh or frozen cranberries in winter.

Gingerbread Cake

2 cups unbleached all-purpose flour

½ teaspoon baking soda

¼ teaspoon salt

1 teaspoon ground ginger

1 teaspoon ground cinnamon

¼ teaspoon ground cloves

6 tablespoons (¾ stick) unsalted butter, at room temperature

½ cup packed dark brown sugar

2 large eggs, at room temperature

½ cup molasses

½ cup very hot water

½ cup finely chopped crystallized ginger

¼ cup bourbon (optional)

Confectioners' sugar, for dusting (optional)

Although gingerbread is considered to be a holiday treat, it's one of those lovely little cakes that can and should be made any time and for any occasion. It's wonderful to serve warm from the oven with a dusting of confectioners' sugar or bourbon-laced whipped cream. It still tastes great even after a day or two, when its flavors have intensified, but chances are this cake won't be around for that long.

1. Position an oven rack in the center of the oven and preheat the oven to 350°F. Grease an 8-inch square baking pan.

2. To make the cake: Sift the flour, baking soda, salt, ginger, cinnamon, and cloves into a medium bowl and set aside.

3. In a large bowl with an electric mixer on medium speed, beat the butter and brown sugar for 2 to 3 minutes, until light and fluffy. Scrape down the sides of the bowl. Beat in the eggs until well blended. Beat in the molasses, hot water, and crystallized ginger. Beat in the bourbon, if using.

Whipped cream (optional)

1 cup heavy cream, chilled

2 tablespoons confectioners' sugar

2 tablespoons bourbon (optional)

4. With the mixer on low, add the flour mixture and beat until just blended (the batter will be stiff).

5. Scrape the batter into the prepared pan and smooth the top. Bake 40 to 45 minutes, or until a toothpick or a cake tester inserted in the center of the cake comes out clean. Transfer the pan to a wire rack to cool for 20 minutes.

6. To make the whipped cream: Beat the cream until it just begins to thicken. Add the confectioners' sugar and bourbon, if using, and beat again until just thick.

7. Cut the cake into squares and serve warm with whipped cream. Or let the cake cool completely in the pan and cover tightly until ready to serve. Dust with confectioners' sugar, if using, and cut into squares.

Makes one 8-inch square cake; serves 8 to 10

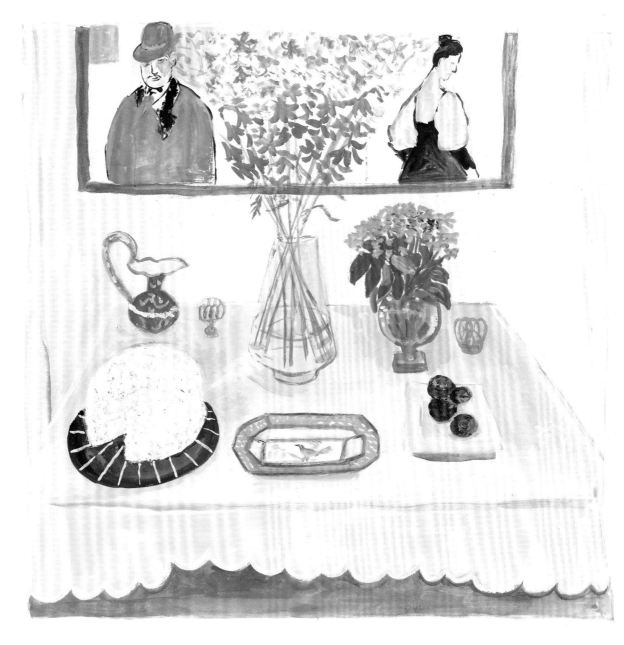

White Layer Cake with Buttercream Frosting

Cake

3 cups cake flour (not self-rising)

1 tablespoon baking powder

½ teaspoon salt

1 cup whole milk

1 tablespoon vanilla extract

2 cups sugar

½ pound (2 sticks) salted butter, at room temperature

5 large egg whites, at room temperature

¼ teaspoon cream of tartar

This white layer cake is the little black dress of cakes. As my mother would have said, "It's perfect for all occasions and you can dress it up or down." I like to serve it with nothing more than a simple buttercream frosting, but you can decorate it to the nines with colorful sprinkles or top it with fresh fruit. You can also add grated orange or lemon zest to the batter to make a white citrus cake. You really can't go wrong with this one, like the perfect little black dress.

1. Position an oven rack in the center of the oven and preheat the oven to 350°F. Butter two 9-inch round cake pans and line the bottoms with parchment paper. Dust with flour and tap out the excess.

2. To make the cake: Sift the flour, baking powder, and salt into a medium bowl. In a small bowl, stir together the milk and vanilla. In a large bowl, with an electric mixer set on high speed, beat the sugar and butter for about 3 minutes, until light and fluffy.

Frosting

5 cups confectioners' sugar

3/4 pound (3 sticks) salted butter, at room temperature

1 teaspoon vanilla extract

3 to 4 tablespoons heavy cream

3. With the mixer on low, beat in the flour mixture in thirds, alternating with the milk mixture, and beating until smooth, scraping down the sides of the bowl as necessary.

4. In another large bowl, using clean beaters, beat the egg whites on high speed with the cream of tartar just until they form stiff, but not dry, peaks. Stir one-third of the beaten whites into the batter to lighten it, then fold in the remaining whites. Divide the batter between the prepared pans and smooth the tops.

5. Bake for 30 to 35 minutes, or until a toothpick or cake tester inserted in the center of the cakes comes out clean. Let the cakes cool on wire racks for 10 minutes. Run a sharp thin knife around the insides of the pans, invert the cakes onto racks, and peel off the paper. Turn the cakes right side up and let cool completely.

6. To make the frosting: Sift the confectioners' sugar into a large bowl. With an electric mixer on low speed, mix in the butter until smooth. Add in the vanilla and gradually mix in enough of the cream to make a spreadable frosting.

7. Transfer one cake layer to a serving plate and spread the top with a small amount of frosting. Top with the other layer; frost the sides and the top, swirling the frosting. Let the cake stand for at least 30 minutes before cutting.

Makes one 9-inch 2-layer cake; serves 8 to 10

Variation

You can make a narrower, taller version of this cake by baking it in three 8-inch round cake pans. Divide the batter among the prepared pans and smooth the tops. The baking time may be a bit shorter than for a 2-layer cake, so start checking for doneness after 25 minutes.

The Cakes of People
I Do Not Know

All over the world, all the time, people are eating cake. They always have and they always will.

A group of children have stopped playing to have cake.

A man taking a nap on a comfortable sofa will wake up to a lovely cake.

Together or alone, celebrating or sitting quietly and thinking, someone is savoring a moment of cake.

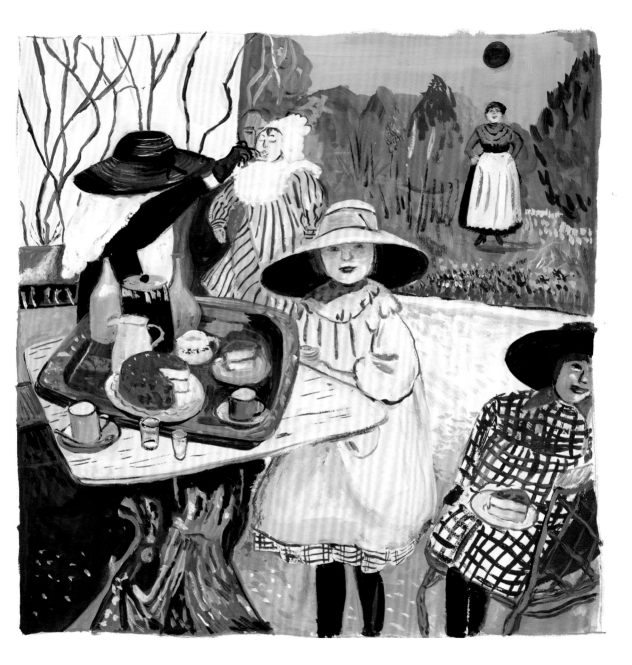

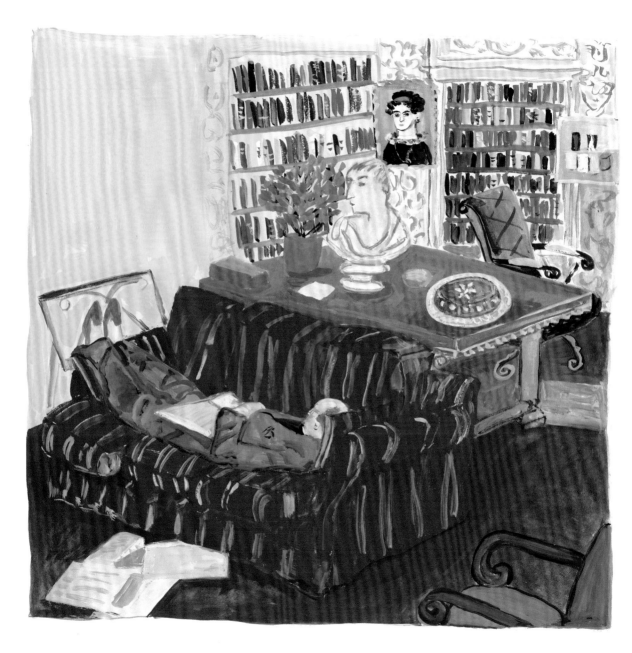

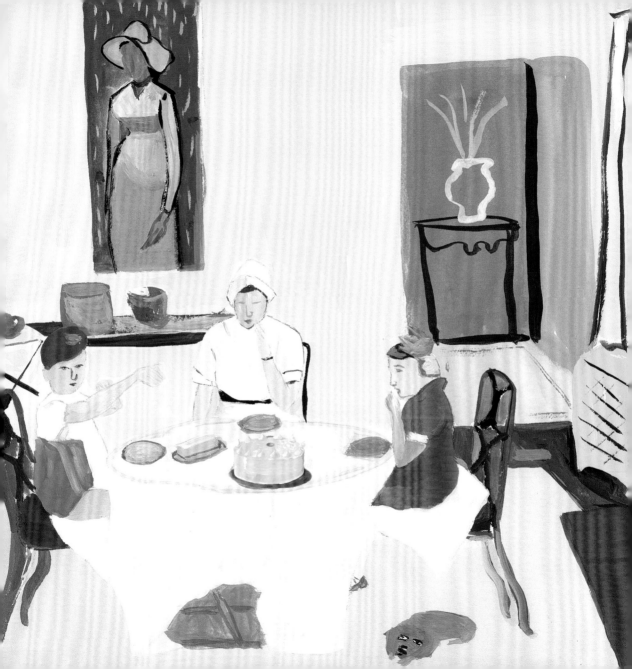

What have I learned?
It is not a party without cake.
It is not a holiday without cake.
It is not an auspicious occasion
without cake.

Things are much nicer with cake.

Bring on the cake.
We Really want to LIVe.

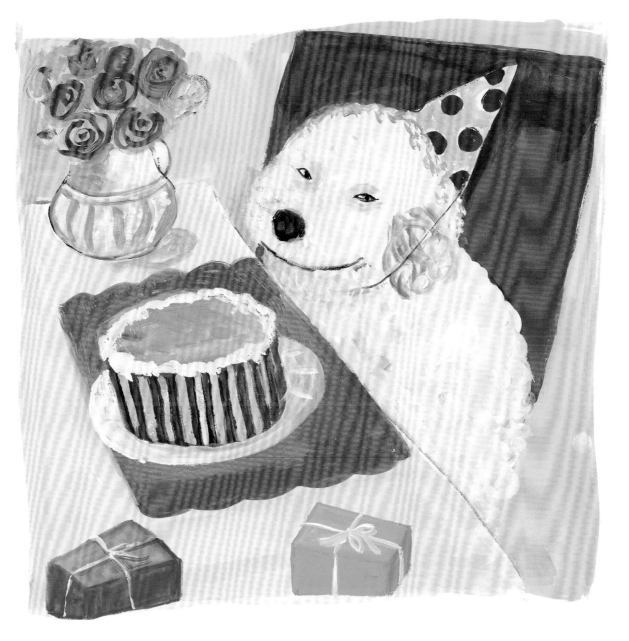

Cake Baking Tips

Getting Started

- Preheat the oven before baking a cake.

- Test the oven temperature for accuracy. Inexpensive oven thermometers are often not accurate. Use a reputable gauge, or more than one.

- Have all ingredients at room temperature, unless otherwise indicated, before mixing a cake.

- Have all ingredients measured, mixed, sifted, or otherwise prepared before you start to bake a cake, so as to have as little delay as possible between steps.

- Use only the pan size and shape designated in the recipe. Different size pans can cause overflow, or not allow proper rising and browning.

- Tread lightly and avoid major activity in the kitchen while cakes are baking.

Ingredients and Measuring

- Use unbleached all-purpose flour. It has not been treated with a bleaching agent, so it is simply more natural and tastes better.

- Use only pure vanilla extract. Its aromatic flavor blends well with other ingredients and doesn't have a strong, medicinal taste, like imitation extract.

- When measuring brown sugar, always pack it down firmly in the cup.

- When measuring sticky ingredients like honey, molasses, or corn syrup, spray the measuring cup with vegetable oil or rinse it out with hot water before adding the ingredient. The sticky ingredient will pour right out.

Mixing and Beating

- When mixing or beating anything with an electric mixer, scrape down the sides of the bowl and the beaters regularly.

Eggs

- Always use Grade A large eggs (unless otherwise stipulated). In most recipes, it is important to have the eggs at room temperature because they incorporate more easily into a batter and whip up better than cold eggs. If your eggs are not room temperature, warm them in a bowl of hot tap water for about 3 minutes before using.

- When beating egg whites, separate the yolks and whites very carefully. If there is even a hint of egg yolk in the whites they will not beat properly. It is unfixable and you will have to start all over again.

- When folding in egg whites, fold in a quarter to a third first to lighten the batter, then fold in all of the remaining whites. This method causes less deflation than folding in all at once. Use a balloon whisk, a large spoon, or a large rubber spatula and cut through the center of the batter, then bring the utensil up the side of the bowl, literally folding the batter into itself. Turn the bowl slightly and repeat until no clumps of whites can be seen. Don't overfold!

- Licking the bowl or spoon of batter containing raw eggs is not a good idea. But if you're making a cake or frosting that doesn't contain eggs, it's fine.

- How do you know if your eggs are fresh? Fill a bowl or saucepan with cold water and gently slide the eggs in. If they sink to the bottom and stay there, they're fresh. If they float to the top, they're not.

Baking and Doneness

- Bake cake layers in the center of the oven, with pans not touching each other or the oven walls.

- Start testing layers for doneness at the shortest suggested cooking time.

- When baking two or more layers, test each one for doneness. Layers in the back of the oven may be ready 2 to 3 minutes before those in the front. Remove each layer as it tests done.

- A cake is done when a cake tester or toothpick inserted in the center of the cake comes out dry, with no crumbs clinging to it, or when the cake springs back when pressed lightly in the center with a finger. The most common tool for testing a cake for doneness is a wooden toothpick. You can also use a cake tester, a thin wire skewer that is specific for this job.

Frosting

- Cool the cake completely before frosting, but frost it as soon as it is cool. If the cake sits too long before frosting, it will begin to dry out.

- Brush loose crumbs from layers before frosting.

- Frosting a cake is easiest if the cake is elevated a few inches off the work surface so you can see what you're doing. You can find a decorating turntable at cake supply shops and online.

- To keep frosting off the serving platter, slip 3 or 4 strips of wax paper under the edges of the bottom cake layer. After frosting, slide out the strips. You will only have to do a light touch-up, if any.

- When frosting two-layer cakes spread about a quarter of the frosting between the layers. For three-layer cakes, use the same amount but spread it thinner.

- An offset metal icing spatula is a good tool for applying frosting, but a simple table knife will do in a pinch.

Whipped Cream

Here are some other tasty ingredients to add to the basic whipped cream recipe on page 34. These flavorings can be added to the whipped cream when you beat in the sugar and vanilla.

- Coffee whipped cream: Add 2 teaspoons espresso powder and a bit more sugar, if necessary, to the whipped cream.

- Cocoa whipped cream: Mix 1 tablespoon unsweetened cocoa powder and 2 teaspoons sugar together with 2 tablespoons heavy cream to form a thick paste. Stir into the whipped cream.

- Maple syrup whipped cream: Substitute 2 tablespoons Grade B pure maple syrup for the sugar.

- Orange whipped cream: Add 1 teaspoon finely grated lemon zest and 1 teaspoon orange flower water to the whipped cream.

- Lemon whipped cream: Add 3 tablespoons chilled lemon curd and a bit more sugar, if necessary, to the whipped cream.

- Cinnamon whipped cream: Add 1 teaspoon ground cinnamon and a bit more sugar, if necessary, to the whipped cream.

- Whipped cream with spirits: Add 2 tablespoons bourbon to the whipped cream. This is especially good with gingerbread and spice cakes. Or add 2 tablespoons rum to the whipped cream. A dollop of rum whipped cream is a good addition to chocolate cakes.

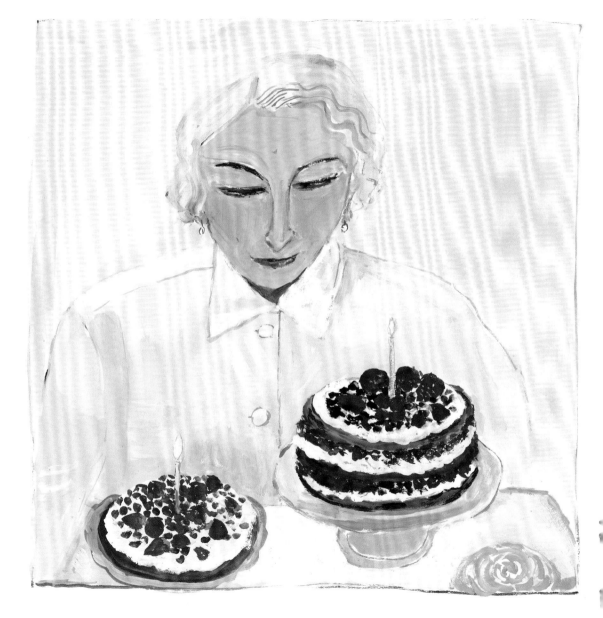

They take the Cake
(in a good way)

Many thanks to my friends – Susan, Bernard,
Cosmo, Rose, Carol, John, Wilson, Bruce, Dirk,
Kari, Michael and Curtis – who ate cake with me
and offered their many thoughts and opinions.
Who knew there were so many opinions about cake?
And to Chelsea Baken, for her thorough and
 excellent cake testing.
And as always, to my beloved "little family".
 B S-G

to Lulu, Alex and now, Olive Orbit Bennett.
Where would I be without them?
 M K

We both are very happy to thank
Charlotte Sheedy, Ann Godoff and Claire Vaccaro
 Cheers!

Bring on the cake.